Color Inspiration from Hand-Painted Style

As you can see on this page, Jenny and William are actually painters! Jenny's adorable puppies, kittens, and wildlife images are created using her own unique style of combining acrylics with brush and airbrushing techniques. William paints daily using gouache and occasionally an airbrush; he finds that the gouache allows for very sharp details and brilliant colors. Check out some of Jenny's and William's original painted versions of the coloring art in this book. You can achieve many of the same effects with colored pencils and markers—seriously! You'll learn how on the next few pages.

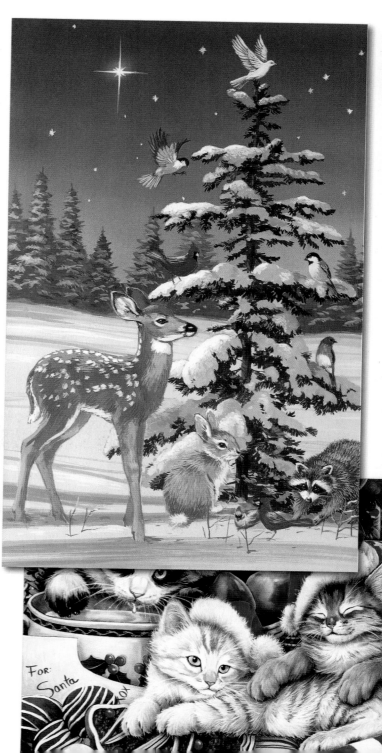

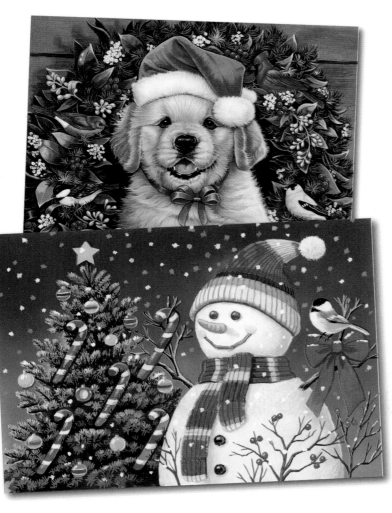

Jenny says, "When working on this book, I enjoyed revisiting my past Christmas-themed paintings to see all of the fun details and animals that I created in each painting. Some of the animals that I drew in my paintings were our family pets, and it brought back a lot of old memories and the paw prints they left on my heart. My children had a lot of influence on the types of ornaments that I used in my compositions. Like the teddy bear riding the toy train, the star ornament adorning a kitten's ear, and the wooden elf skiing down a popcorn and cherry garland—these were all inspired by my darling children and their fun imaginations."

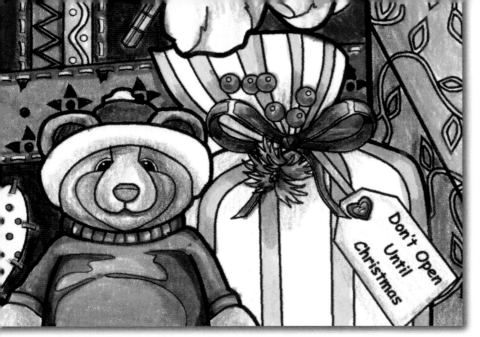

Getting Started: Choosing Colors

Art, coloring, and drawing are meant to be fun. Don't stress too much about it. Here are a few tips to help you get started.

Use a Limited Color Palette. Choose four to seven colors for your palette. Start with five colors, then add two if you are working on a large drawing with lots of details. If it's a simpler drawing, subtract one color from your palette.

Here are the basic colors used in the detailed piece above.

Choose a Dominant Color. The dominant color in a piece is the color that stands out the most. It is the color people will remember.

Red is the dominant color in the piece above.

Build Around the Dominant Color. Your other colors should typically include shades that are both lighter and darker than the dominant color, unless your dominant color is very dark or very light. Some of the colors you choose will complement each other, and some will clash with one another. The important thing is that they all look nice when they've been used together on the page.

Here are the colors that were used to build around the dominant color in the piece above.

Pick a Light or Neutral Shade. Light or neutral shades help add highlights and make the other colors pop. These are colors such as light gray, light beige, or yellow. And don't forget that white is also a good neutral color!

White is the neutral shade used in the piece above.

Pages 2–5 by Jenny Newland.

Helpful Hints

Get Inspired.

If you are having one of those days when you are stuck, the colors aren't coming, your drawing stays blank, and every time you try to make a color palette it just doesn't look right... well, I know exactly what that's like, because I have those days as well. You need a little bit of inspiration. Step outside and be inspired by nature, thumb through your favorite decorating magazine, or visit your favorite clothing or home store to see all the trending colors. You'll be surprised how quickly inspiration can strike!

Backgrounds and Borders.

The background or border of a piece is usually the darkest or the lightest color in your color palette. It's a good idea to choose your background

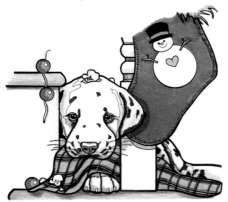

color first during your color selection. If you're going to pick a dark color for the background, you want to make sure the rest of your colors are going to be lighter so there will be nice contrast. Don't forget, though, that you can use white as your background—it's easy and effective.

Always Test Your Colors.

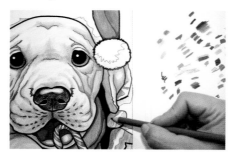

This tip is so simple, but people often forget it! Always test your colors before starting to color on the actual design. Test them to see what they actually look like—sometimes the color label doesn't look exactly like the result. Test them to make sure they go together. Test tools together if you're going to layer different media on top of one another. Just test every step of the way! You'll thank yourself.

Add Some Basic Shading.

Adding a little bit of shading helps to enhance your drawings and give them extra dimension and life. You can apply shading to other types of drawings, but I'm specifically focusing on shapes. You may not want to spend hours building up shading in your drawing, so just pick a particular

area to apply your shading. It will add a little something special. See the next page for ways to achieve shading!

Spread the Color Evenly.

Remember to spread your colors evenly to create a balanced look. If you use too much of one color on one side of the drawing and don't spread it around to other areas of the drawing, it can become unbalanced. You can start in the center of your piece or in a corner—whatever works best for the drawing. You can turn the drawing around or hold it a little bit away from you to see how the colors are working. Spreading your colors evenly will give your drawing a more professional look.

Don't Give Up!

Don't give up on a piece. It's really easy to do; I've done it many times. I start coloring, lay down a strong color, and then decide I've ruined it. My immediate reaction is to tear it up and start again, but don't do that! Most of the time, once you've distributed that strong color and all the rest of your colors, it will work. Somehow it just comes together. For every time you really have "ruined" a piece, there will be five more times when it turns out nicely.

Layering and Blending

I enjoy layering and blending colors. It's a great way to enhance your drawing and give it extra dimension and life. Simply working from the lightest color to the darkest color can add depth to the object you are coloring. Here are several examples to show you how to layer and blend different shapes. For each example, start with two or three colors as shown to the right.

1 Outline three quarters of the shape with the light color.

2 Apply a base layer all over the shape with the middle color. Don't color the highlights or over top of the light color.

3 Add the darkest color to part of the middle color like a shadow, giving your shape depth.

4 Use the middle color again to blend the dark and middle colors together.

1 Apply a base layer with the lightest color. Leave some white patches to show the glint of light.

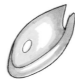

2 Add the middle color, outlining the shape and shading heavier on one end.

3 Add the darkest color on one end, giving your shading even more depth.

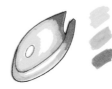

4 Use the middle color again to blend the dark and middle colors together.

1 Pine branches can be tricky to color. Here are some tips.

2 Draw in guidelines with the middle color to help form the shape of the individual needles.

3 Trace the guidelines with the middle color to thicken the lines, leaving some white patches.

4 Add the lightest color to the white patches, and then add the darkest color in the very center and base of the pine needles.

1 Here we'll define pine branches within the mass of a tree. First, trace around the branches with a dark color, such as black.

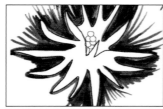

2 Add thin lines to create the illusion of other pine needles.

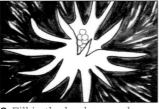

3 Fill in the background with the dark color, leaving some thin white patches around the branches.

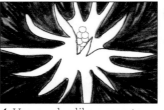

4 Use a color like green to fill in the white patches.

Now for what you've been waiting for: how to color a true Christmas cutie face! Follow along to see how to achieve a realistic, pretty fur effect. Before getting started, select four different colors, as shown alongside step 4. For beginners, colored pencils are a good choice; they give you a bit more freedom when blending.

1 Apply a base layer with the lightest color. Color all the fur that you want to end up being colored—you can leave some fur white as shown in this example.

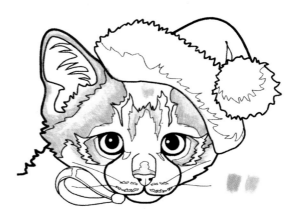

2 Add the middle color. Blend the middle color into the lighter color, but be sure to leave some of the lighter color showing. Make your pencil strokes in the direction that real fur grows.

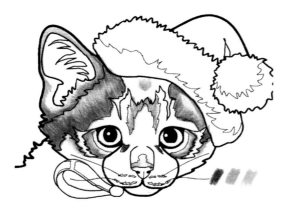

3 Add the darker color in the same way as you did the middle color. Blend the darker color into the middle color, but be sure to leave some of the middle color showing.

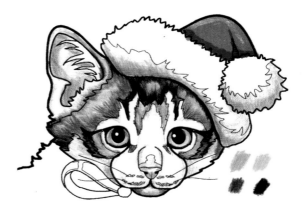

4 Add the darkest color. This will really make the other colors pop! The darkest color should be used sparingly; a little goes a long way.

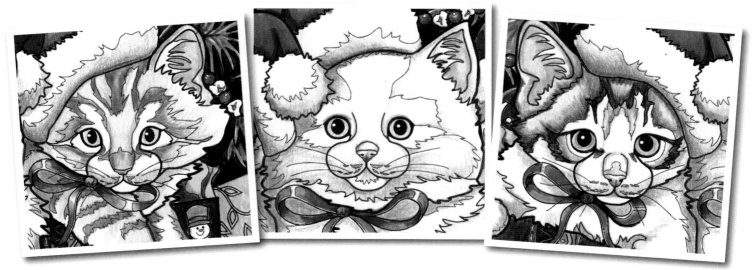

5

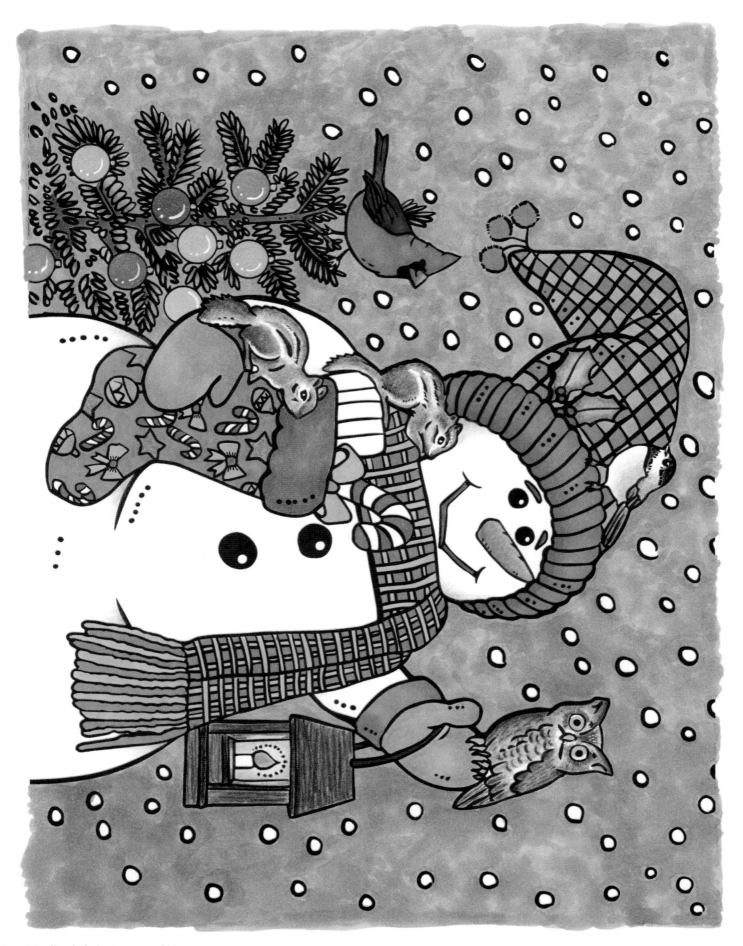

Woodland Christmas, page 33.
Markers (Spectrum Noir), colored pencils (Prismacolor), gel pens. Color by Lisa Caryl.

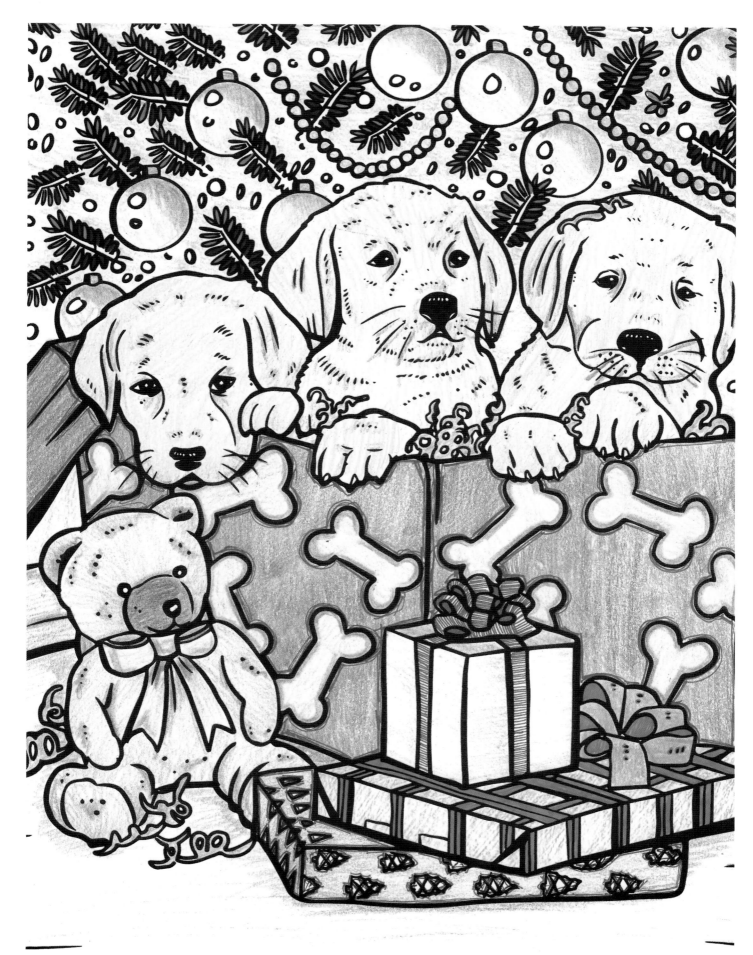

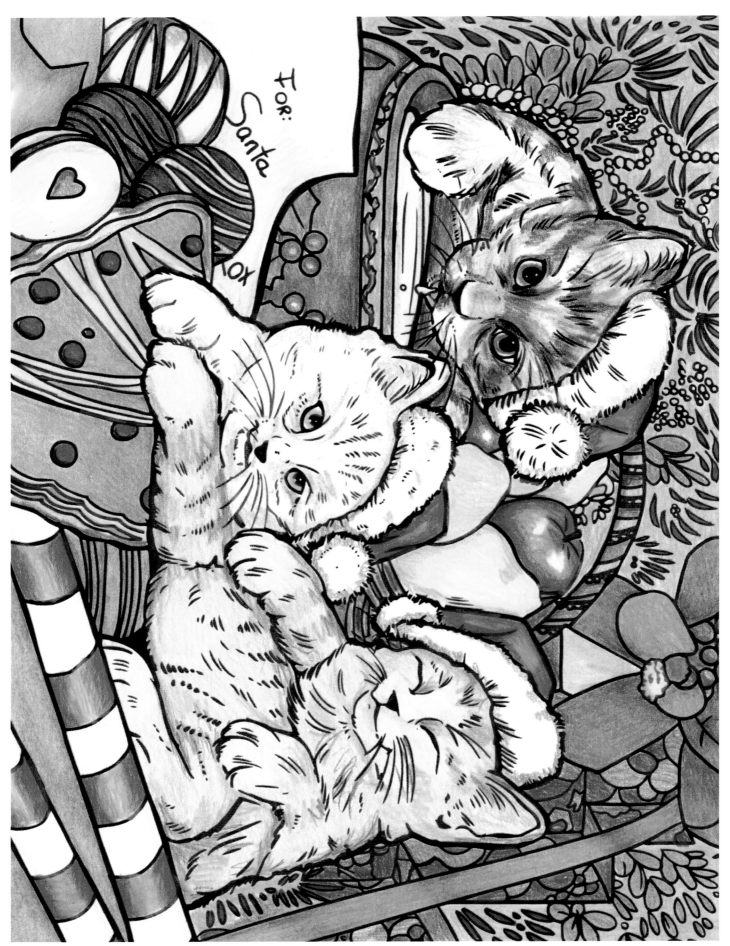

8 Waiting for Santa, page 37.
Colored pencils (Prismacolor), markers. Color by Darla Tjelmeland.

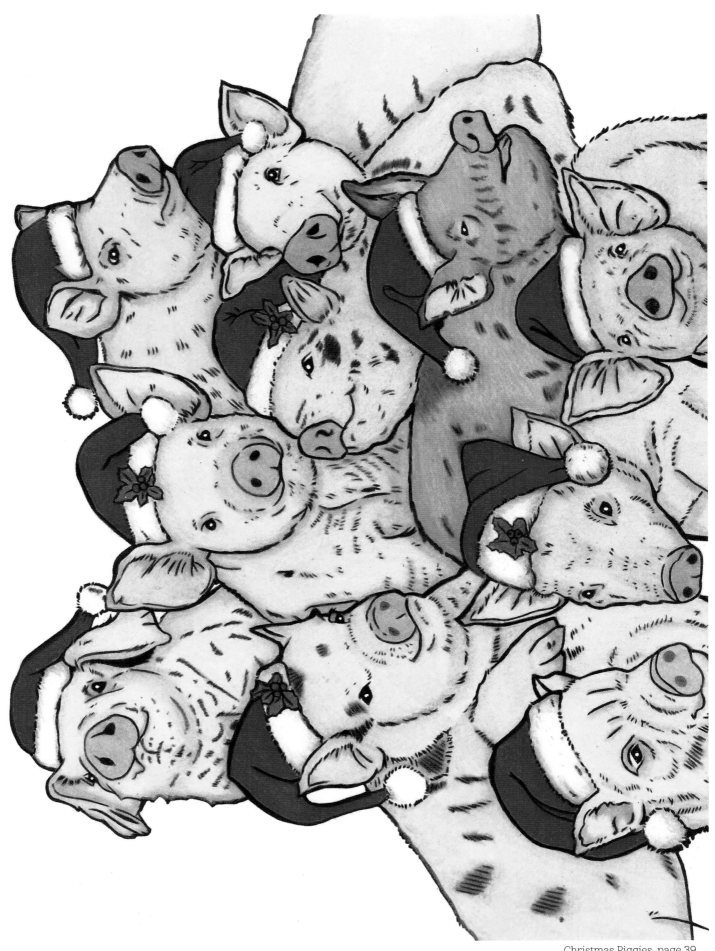

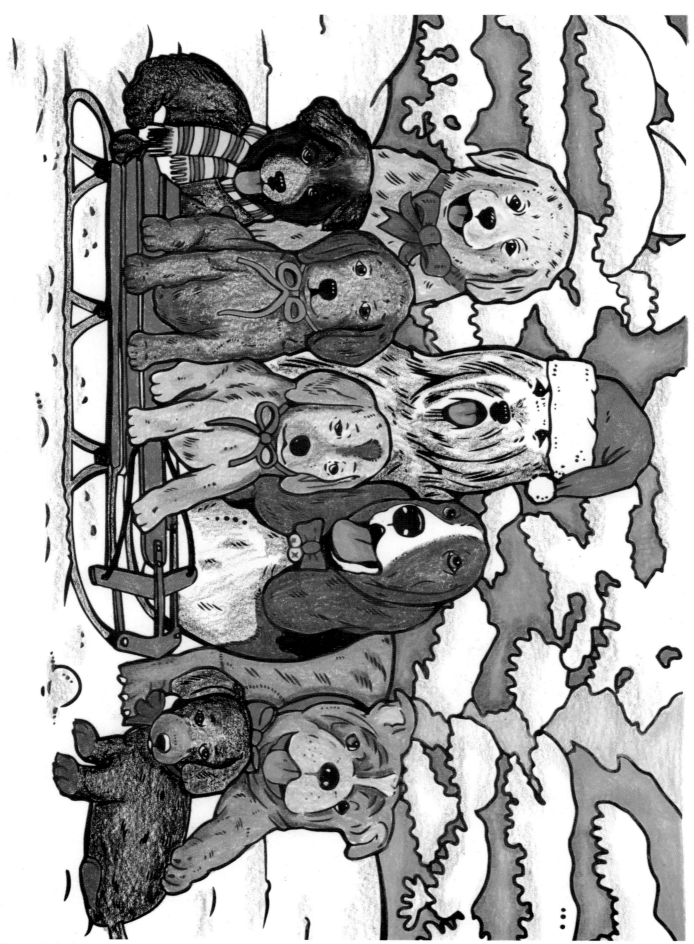

10 Playing in the Snow, page 41.
Colored pencils (Prismacolor). Color by Sarah von Schmidt-Pauli.

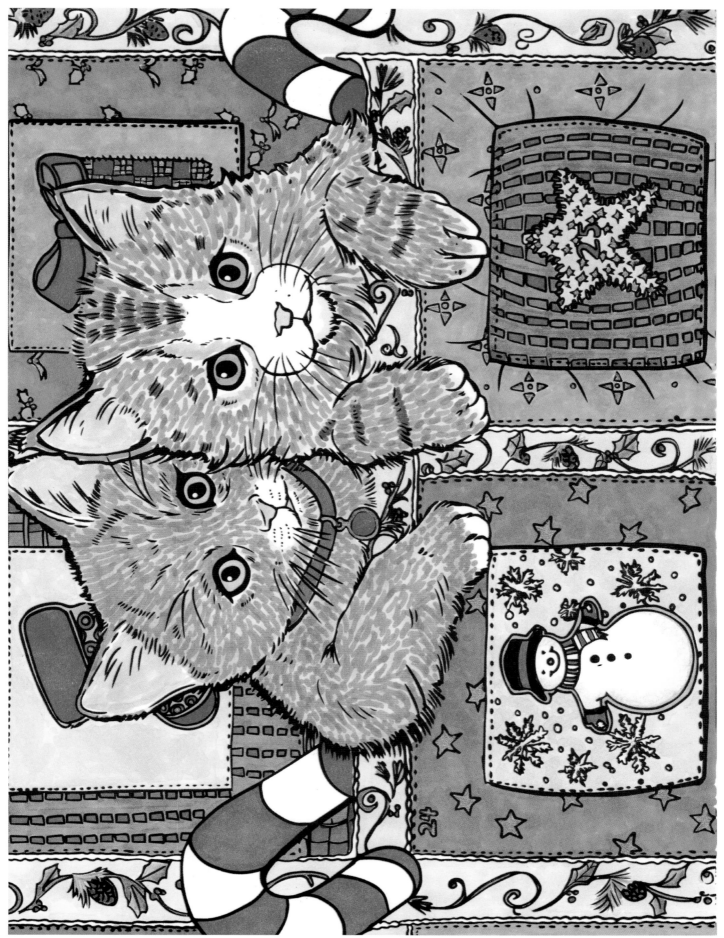

Markers (Spectrum Noir), colored pencils (Prismacolor), metallic gel pens. Color by Lisa Caryl.

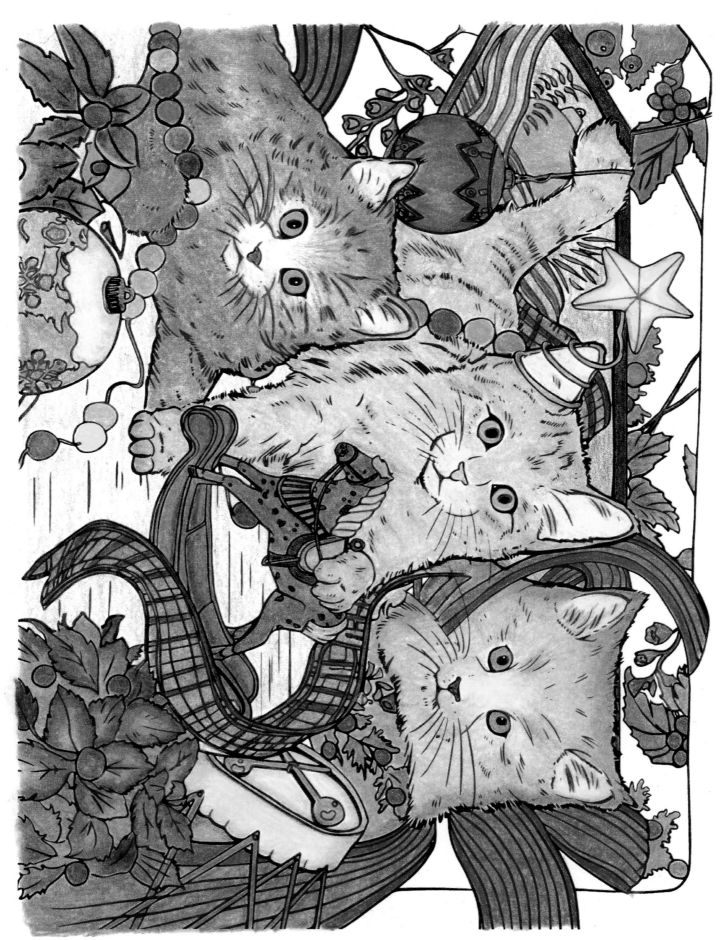

12 Christmas Fun, page 45.
Colored pencils (Prismacolor, Faber-Castell). Color by Lynette Parmenter.

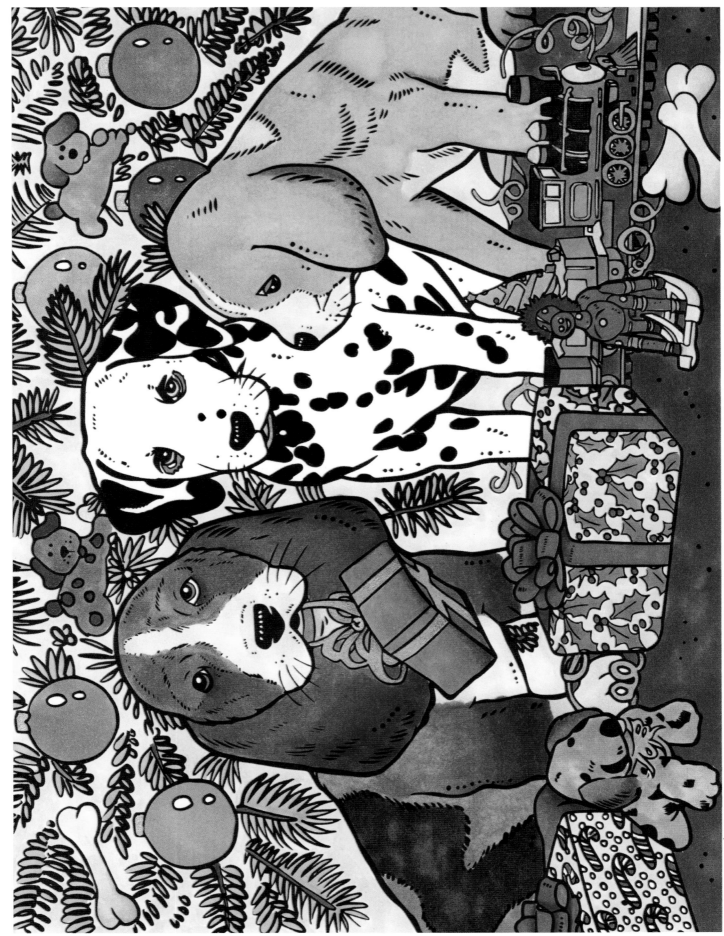

Markers (Spectrum Noir), colored pencils (Prismacolor), glitter markers (Wink of Stella), gel pens. Color by Lisa Caryl.

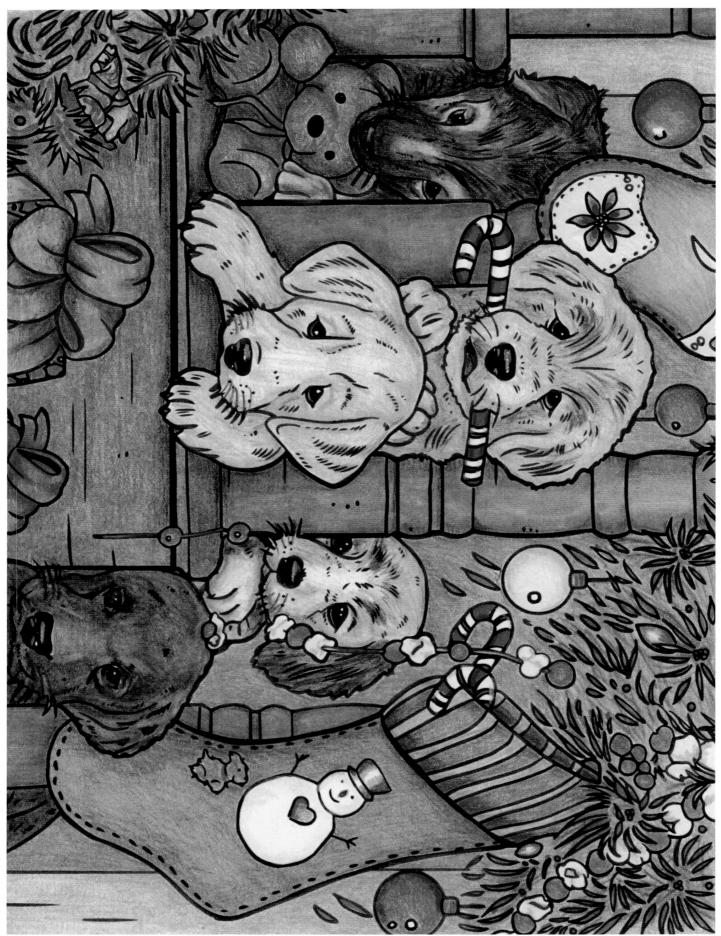

Did Santa Come?, page 71.
Colored pencils (Prismacolor). Color by Darla Tjelmeland.

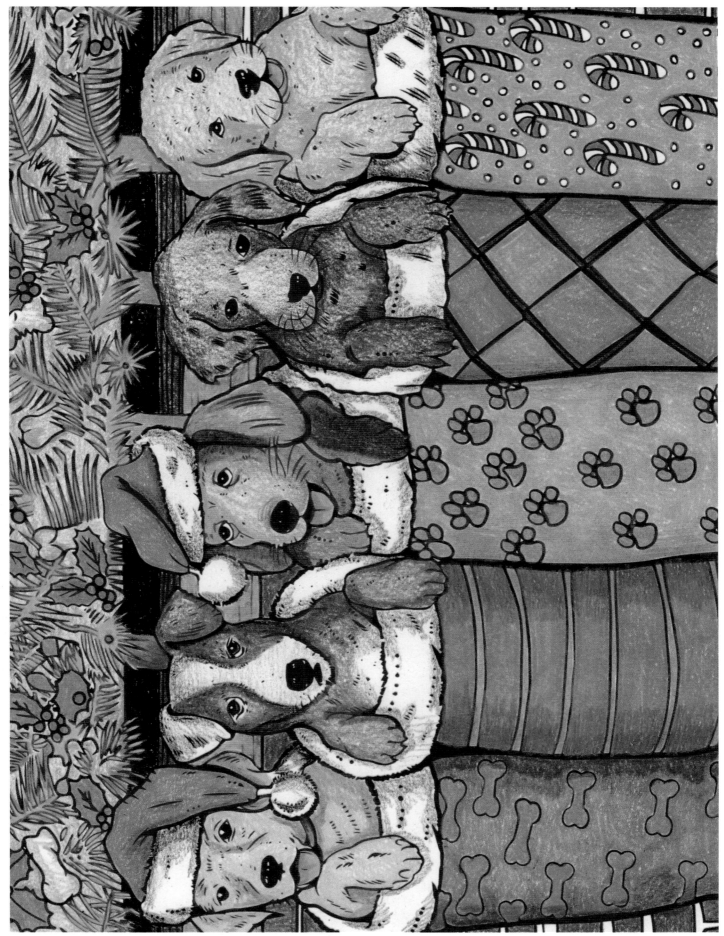

Colored pencils (Prismacolor). Color by Sarah von Schmidt-Pauli.

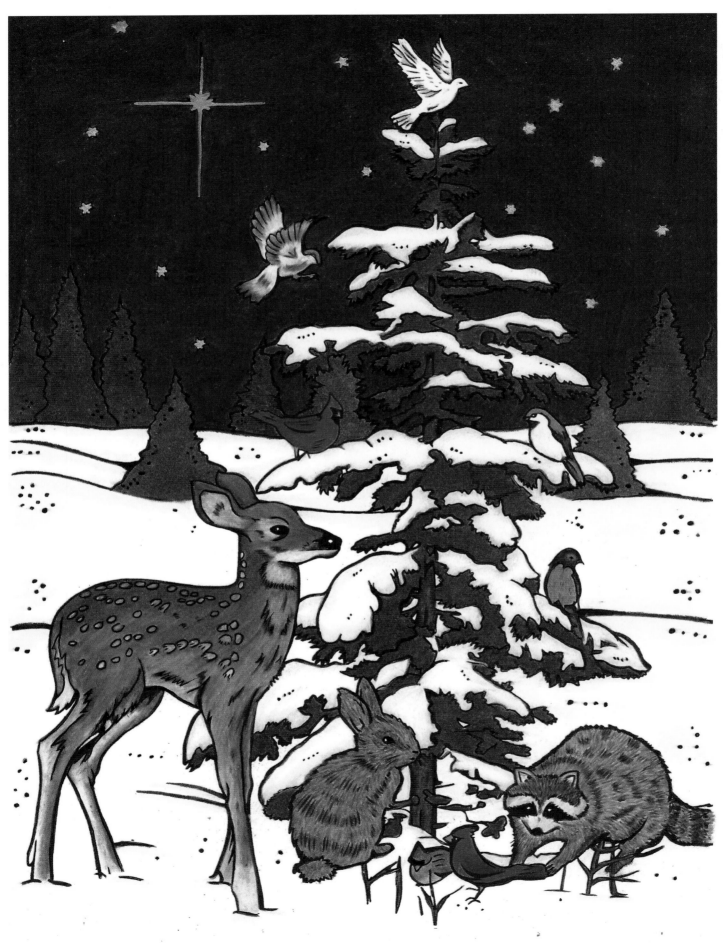

Blessed Night, page 21.
Colored pencils (Prismacolor). Color by Kelly Nagorka.

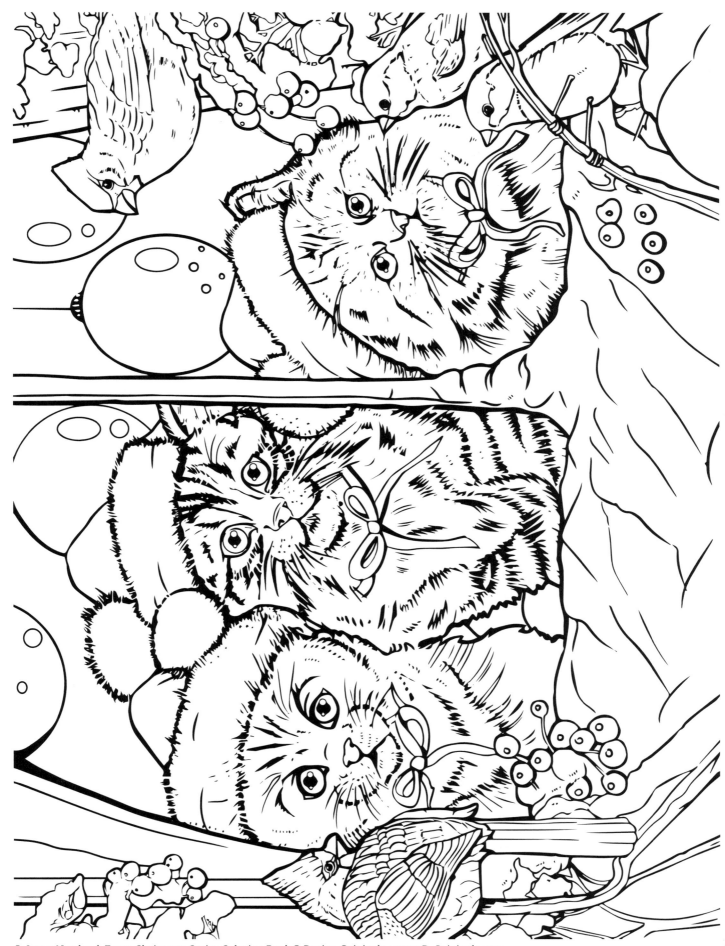

Each sight, each sound of Christmas
And fragrances sublime
Make hearts and faces happy
This glorious Christmastime.

—Carice Williams

Everyone thinks they have the best dog,
and none of them are wrong.

—W. R. Purche

Sweet Treat

Peace on Earth will come to stay,
when we live Christmas every day.

—Helen Steiner Rice

Blessed Night

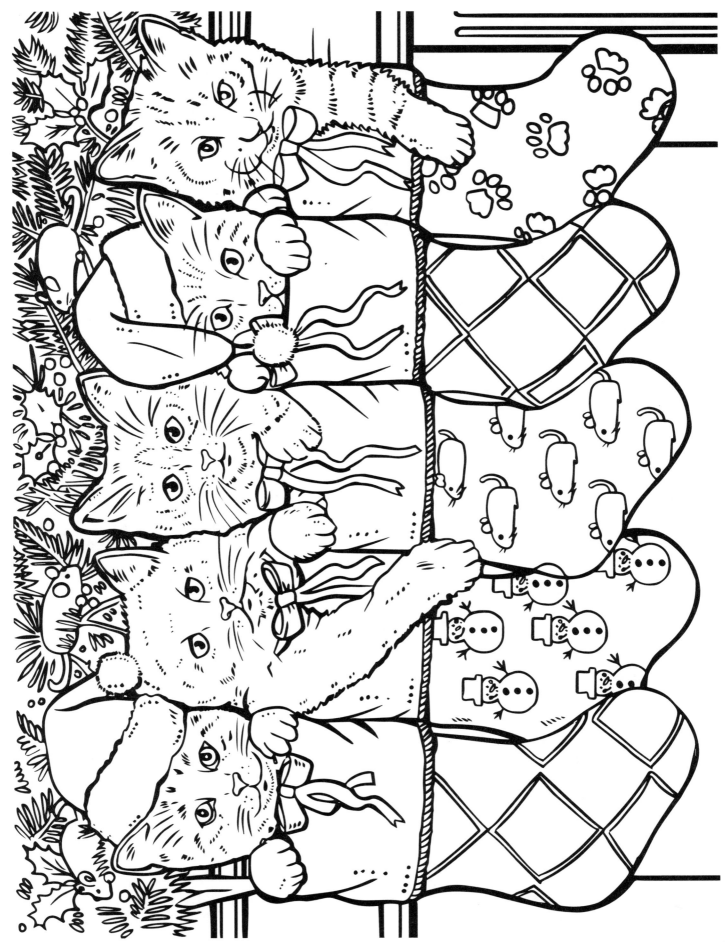

Before a cat will condescend
To treat you as a trusted friend,
Some little token of esteem
Is needed, like a dish of cream.

—T. S. Eliot, *Old Possum's Book of Practical Cats*

Stocking Stuffers

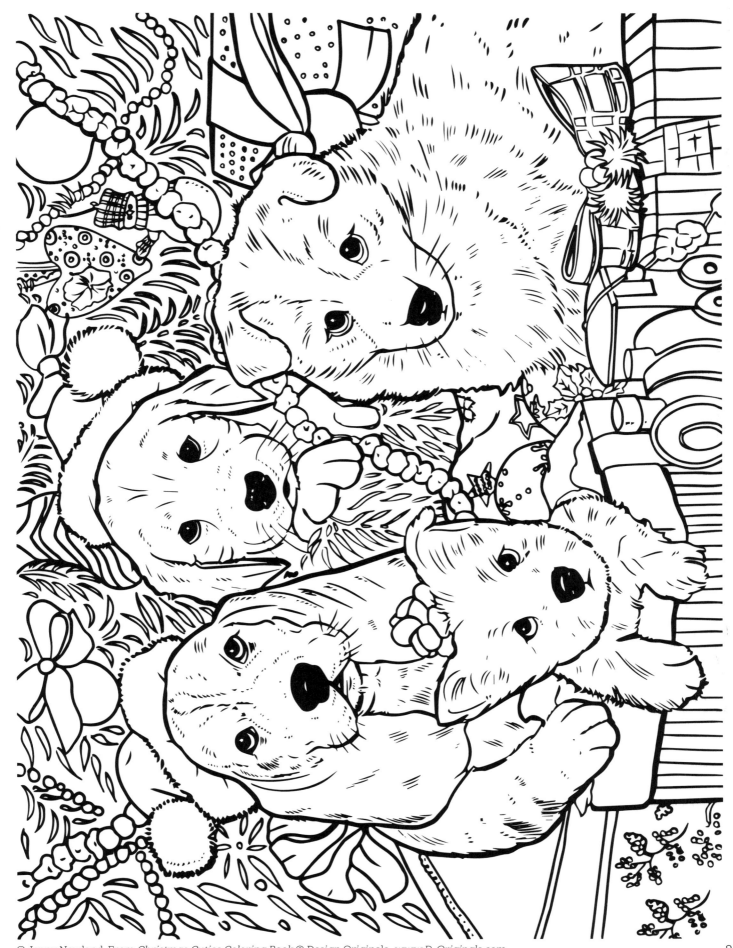

And, so, Christmas comes to bless us!
Comes to teach us how to find
The joy of giving happiness
And the joy of being kind.

—Gertrude Tooley Buckingham, *There Will Always Be a Christmas*

Puppy Love

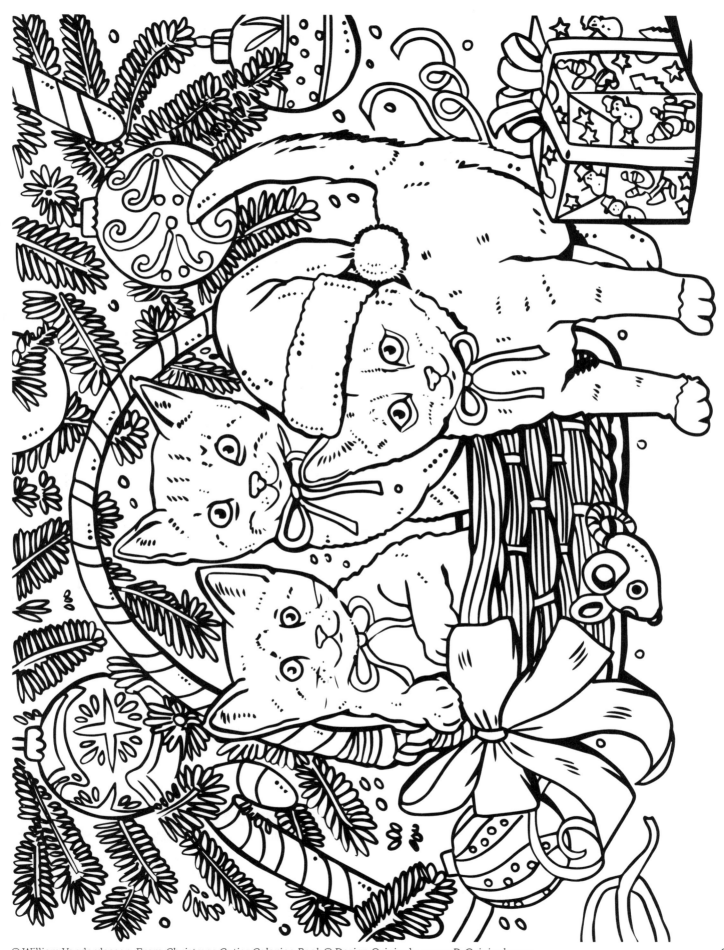

A kitten is the delight of a household. All day long a comedy is played out by an incomparable actor.

—Champfleury, *The Cat, Past and Present*

Basket o' Kitties

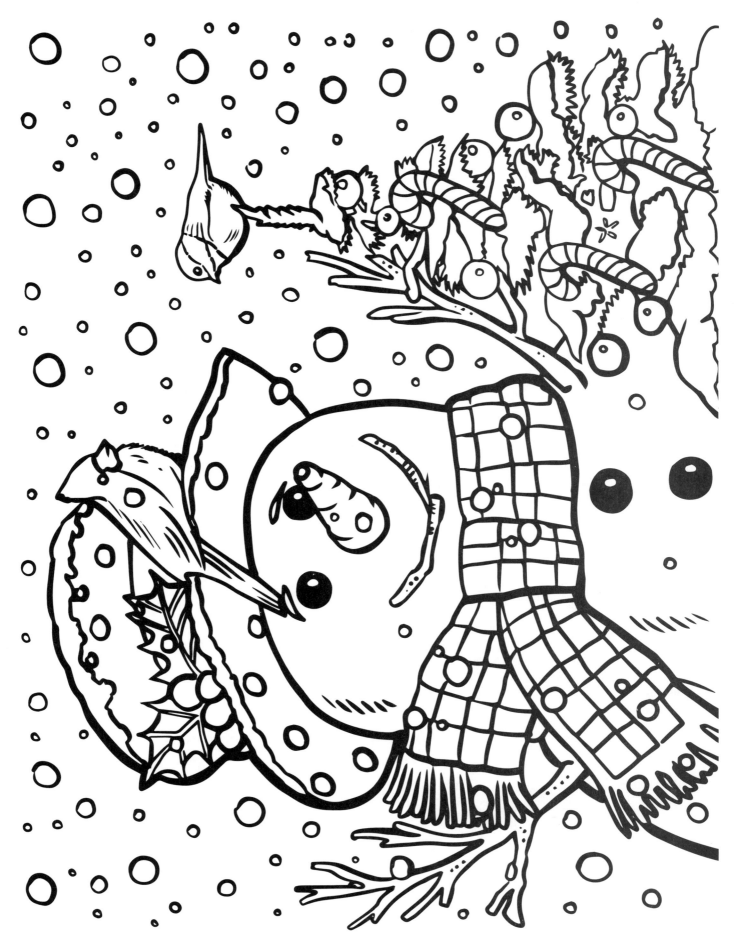

Do you want to build a snowman?

—Frozen

Grandma's Scarf

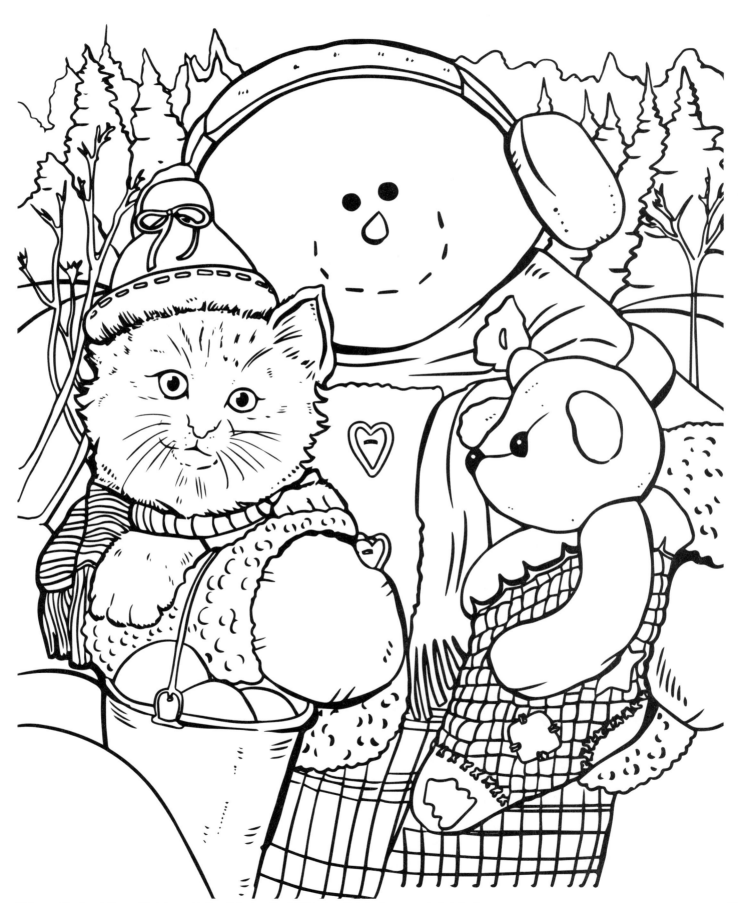

What greater gift than the love of a cat?

—Charles Dickens

Winter Friends

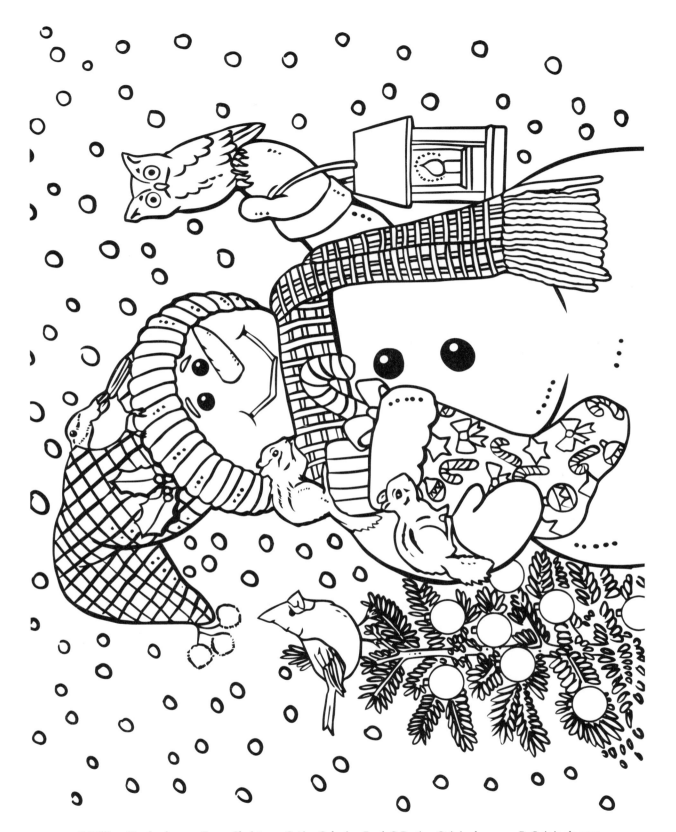

Christmas waves a magic wand over this world, and behold, everything is softer and more beautiful.

—Norman Vincent Peale

Woodland Christmas

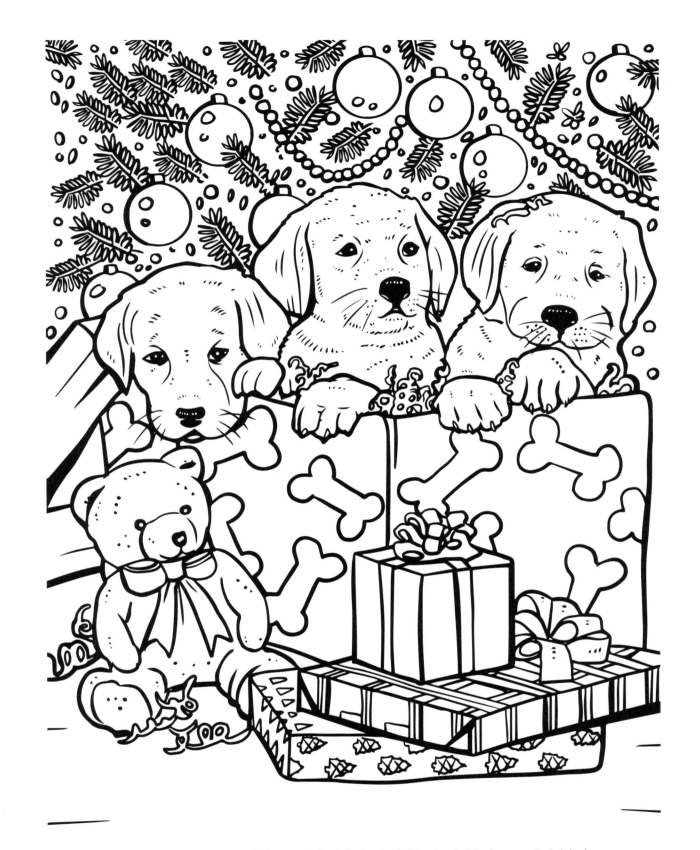

The best way to get a puppy is to beg for a baby brother—and they'll settle for a puppy every time.

—Winston Pendleton

The Cutest Gifts

© Jenny Newland. From *Christmas Cuties Coloring Book* © Design Originals, *www.D-Originals.com*

Cats are connoisseurs of comfort.

—James Herriot, *James Herriot's Cat Stories*

Waiting for Santa

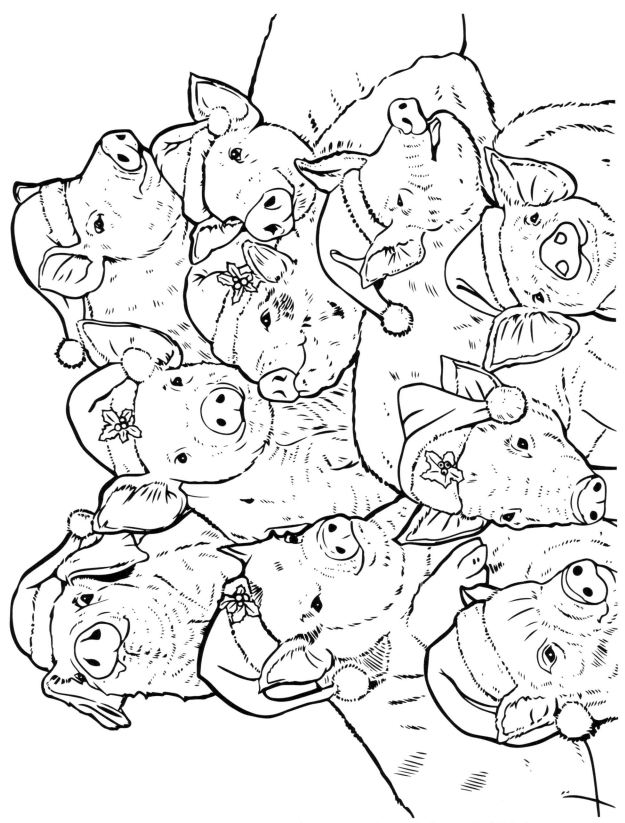

© Jenny Newland. From *Christmas Cuties Coloring Book* © Design Originals, *www.D-Originals.com*

At Christmas play and make good cheer,
For Christmas comes but once a year.

—Thomas Tusser

Christmas Piggies

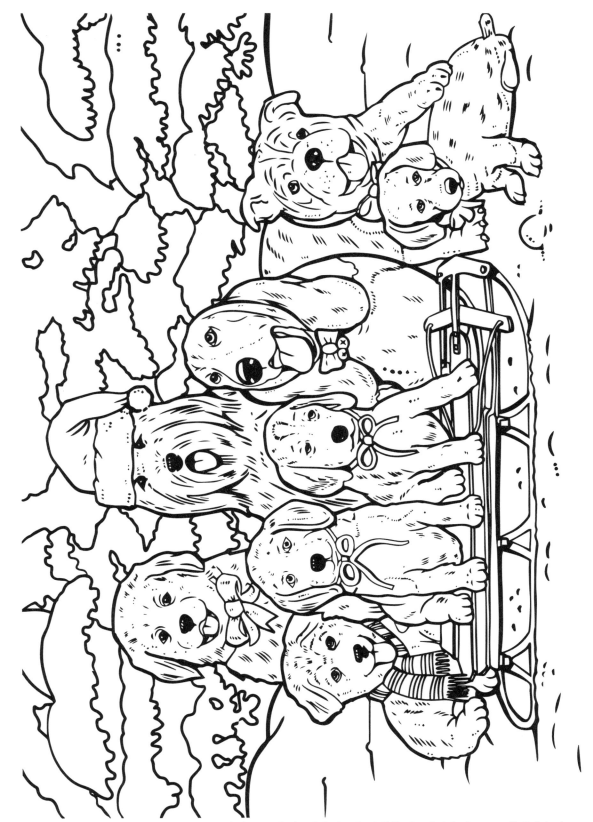

© William Vanderdasson. From *Christmas Cuties Coloring Book* © Design Originals, *www.D-Originals.com*

Snowflakes are one of
nature's most fragile things,
but look at what they can do
when they stick together.

—Unknown

Playing in the Snow

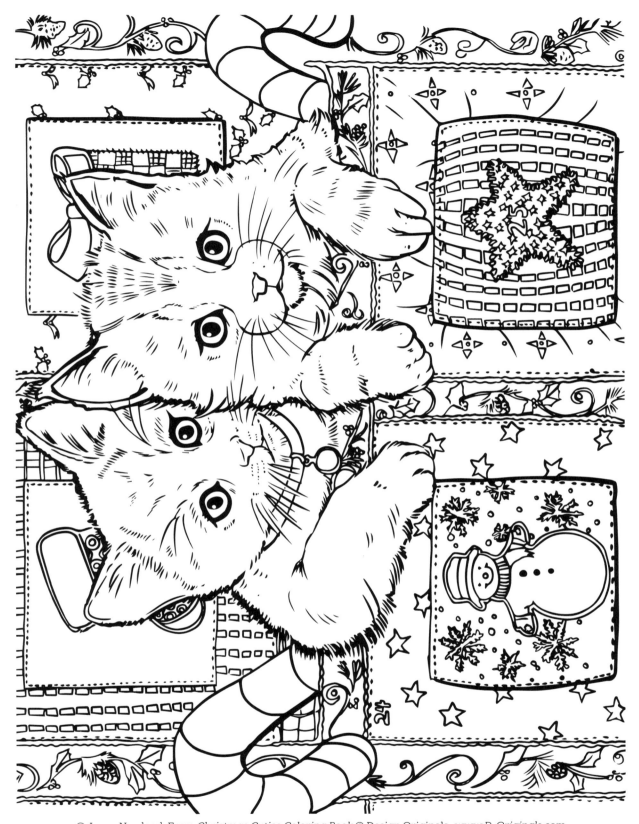

© Jenny Newland. From *Christmas Cuties Coloring Book* © Design Originals, *www.D-Originals.com*

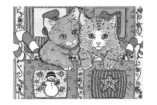

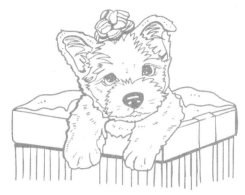

I love the excitement, the childlike spirit of innocence, and just about everything that goes along with Christmas.

—Hillary Scott

Countdown to Christmas

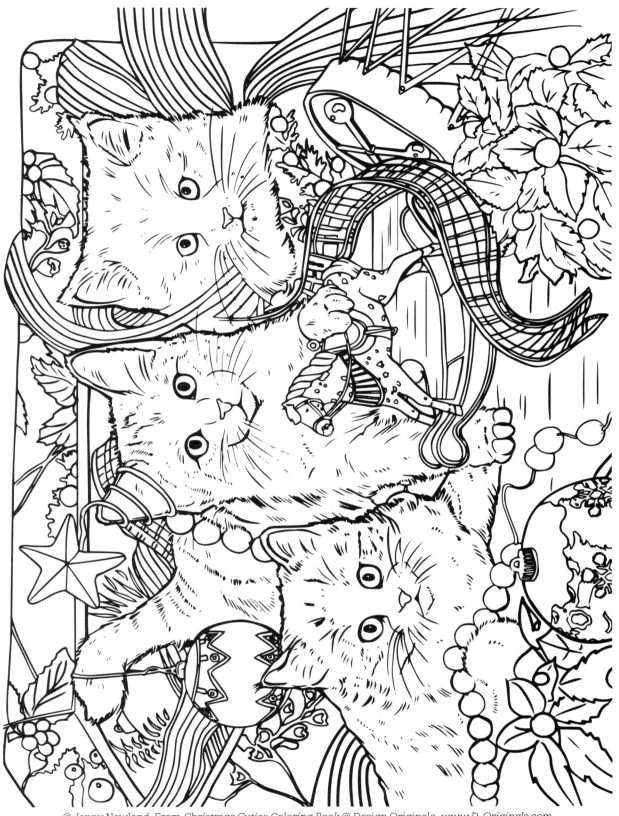

In a cat's eye, all things belong to cats.

—English proverb

Christmas Fun

© William Vanderdasson. From *Christmas Cuties Coloring Book* © Design Originals, *www.D-Originals.com*

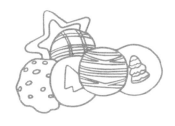

This is the message of Christmas:
we are never alone.

—Taylor Caldwell

Time to Open Presents

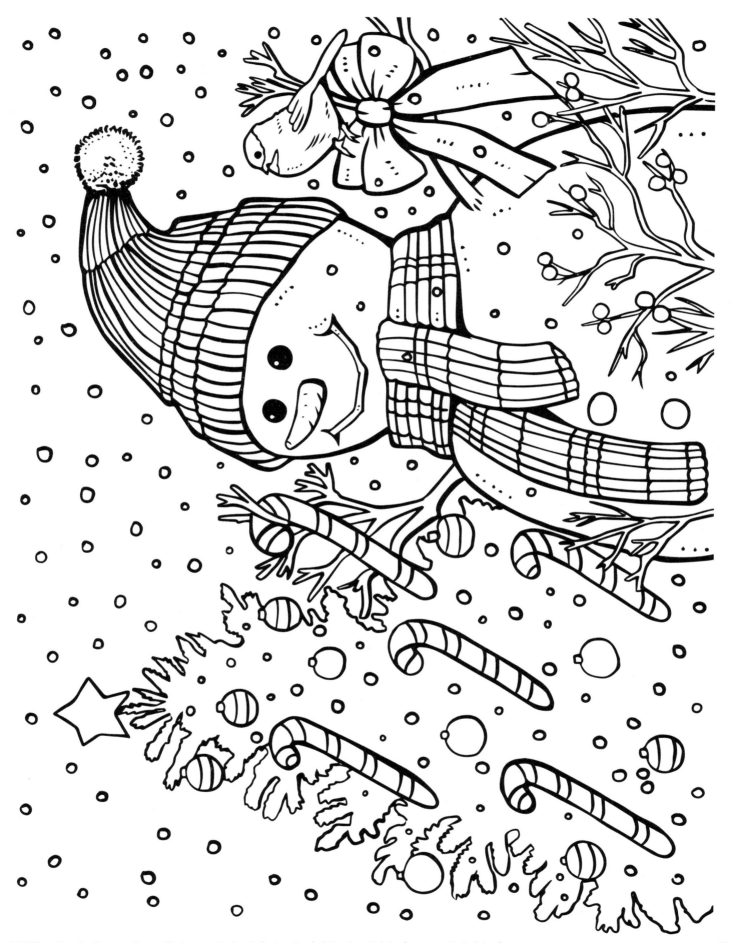

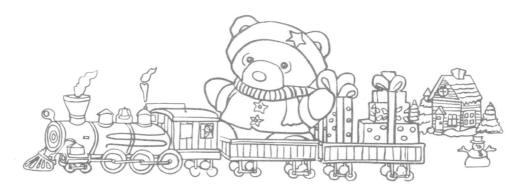

I'm dreaming of a white Christmas, just like the ones I used to know, where the tree tops glisten and children listen to hear sleigh bells in the snow.

—Irving Berlin, *White Christmas*

Star on Top

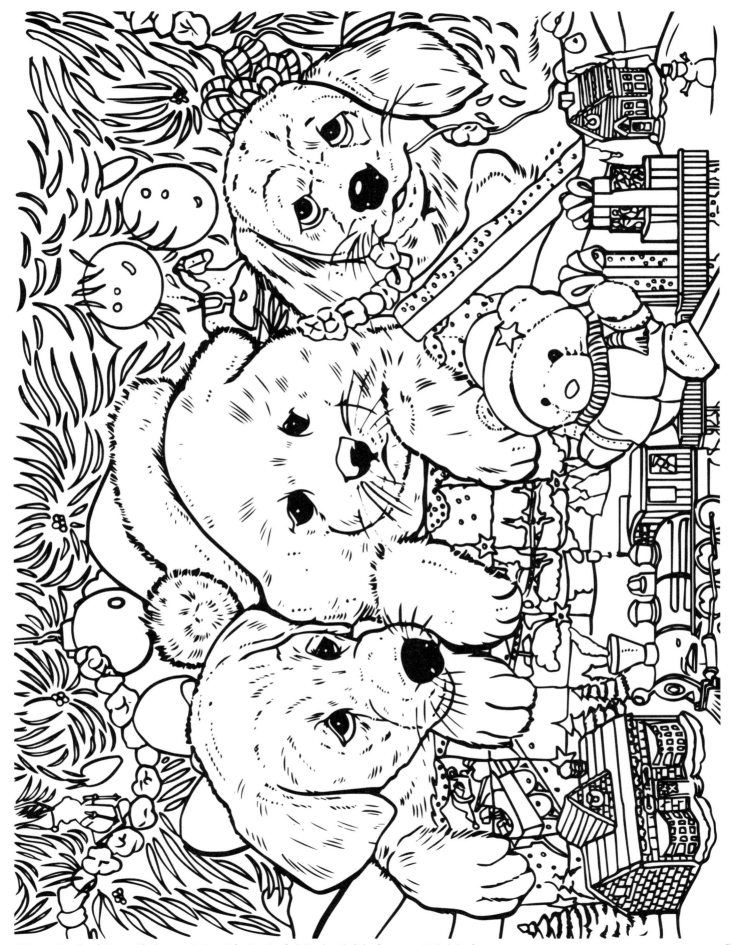

51

Our hearts grow tender with childhood memories and love of kindred, and we are better throughout the year for having, in spirit, become a child again at Christmas-time.

—Laura Ingalls Wilder

Under the Tree

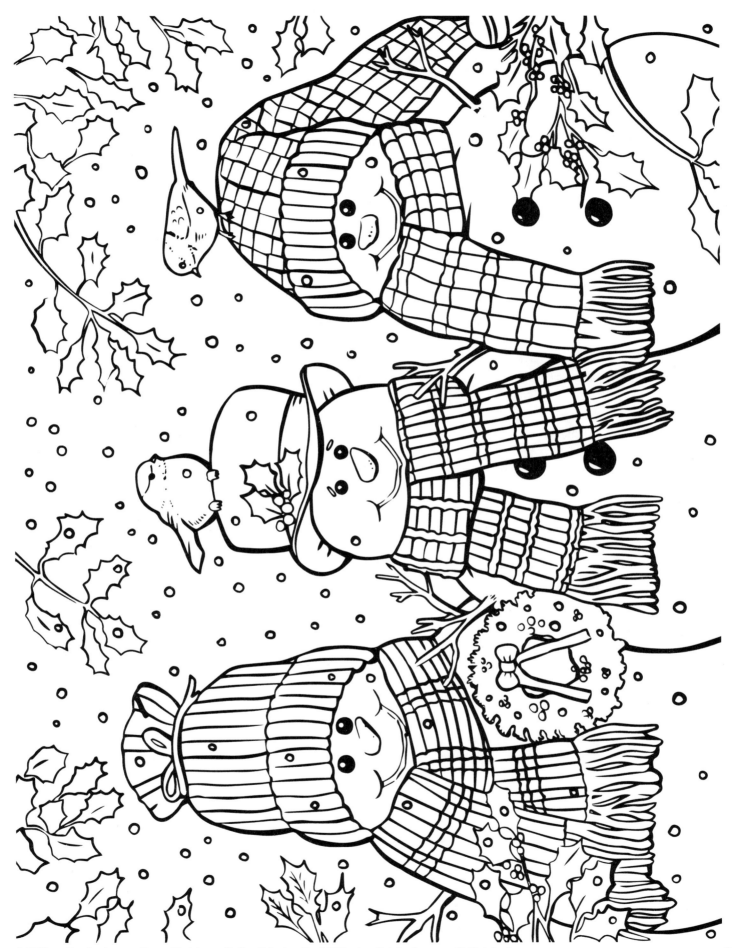

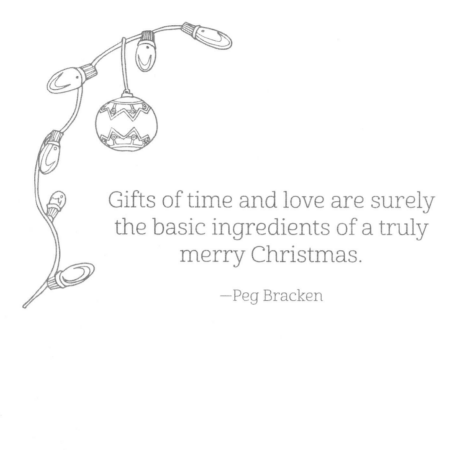

Gifts of time and love are surely
the basic ingredients of a truly
merry Christmas.

—Peg Bracken

Snowman Trio

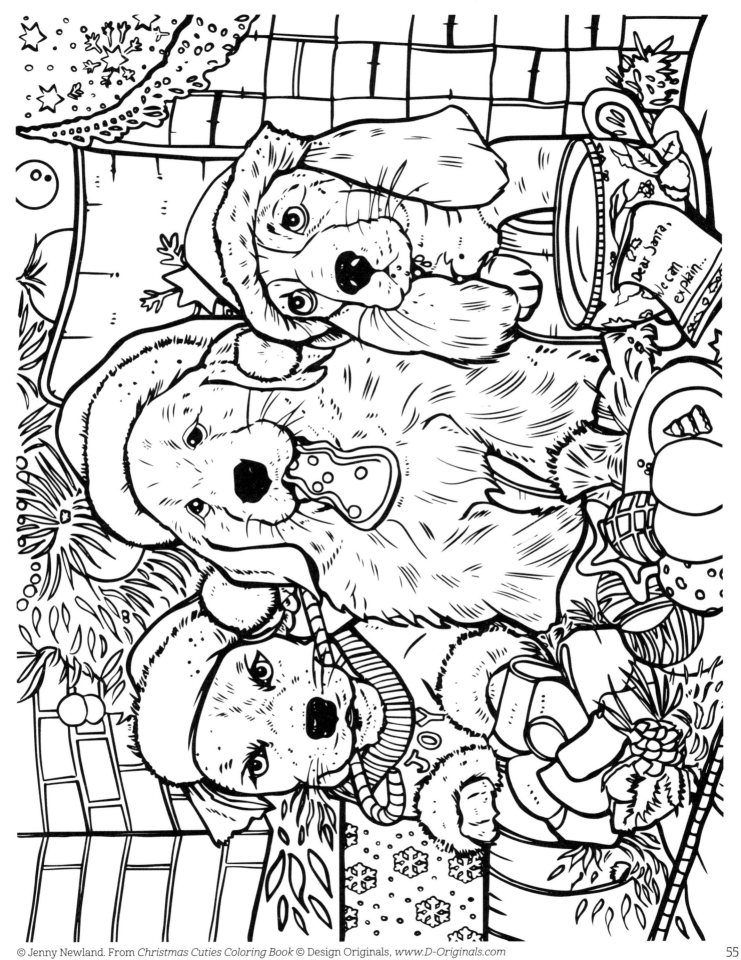

Hope your Christmas is as warm
and sweet as a cup of hot cocoa and filled with
more granted wishes than you can count.

—Unknown

Dear Santa

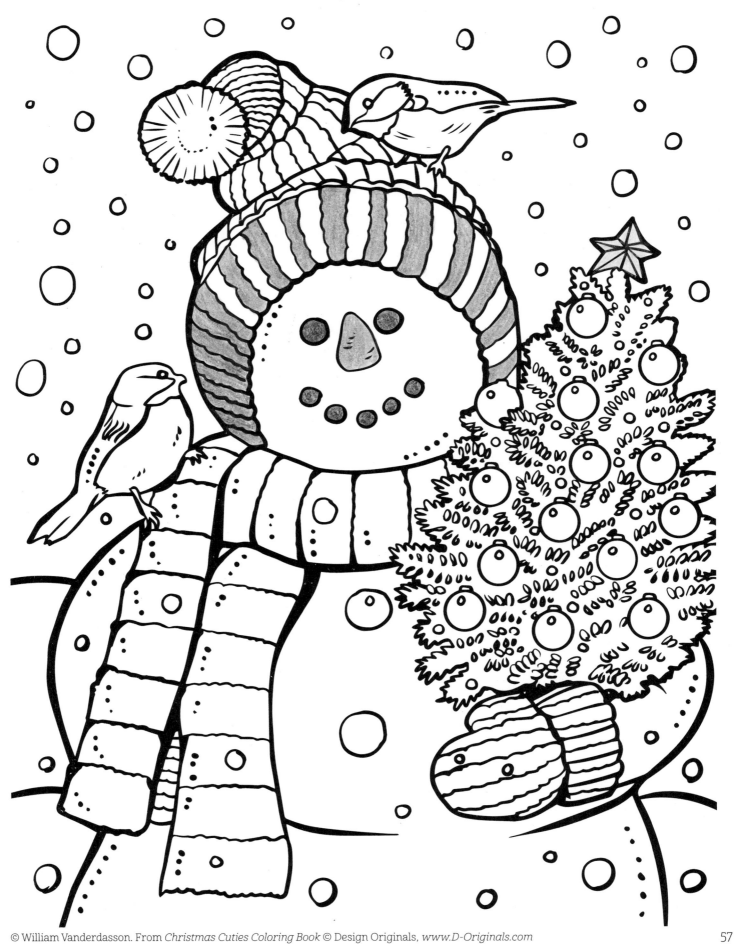

To make a winter friend
Find a carrot and some coal.
Gather up your friends
And roll a bunch of snow!

—Unknown

Bundled Up

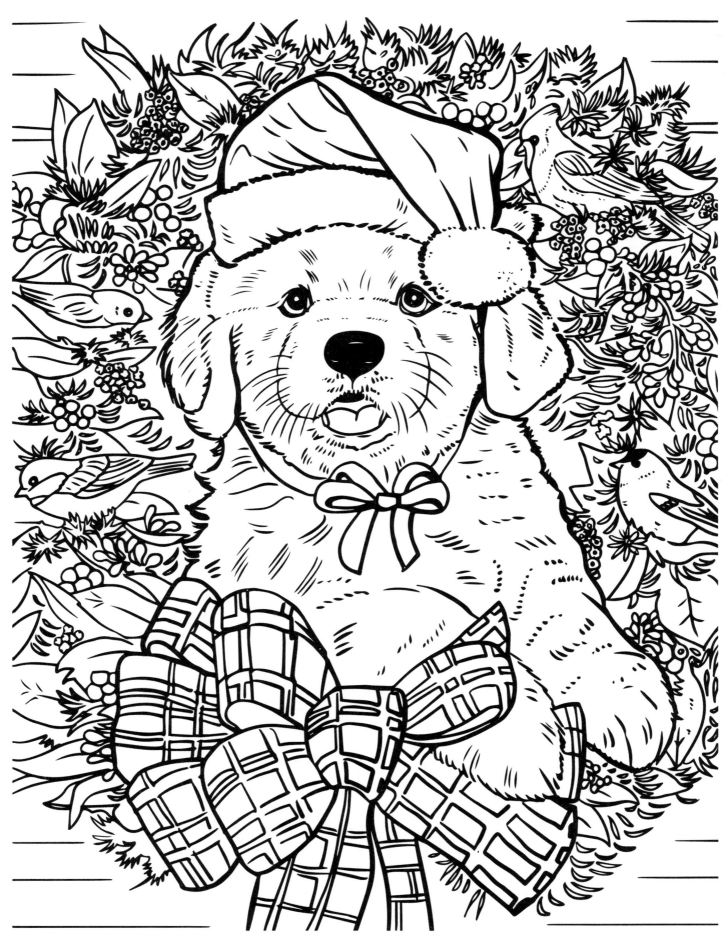

A puppy is but a dog, plus high spirits, and minus common sense.

—Agnes Repplier

Puppy Wreath

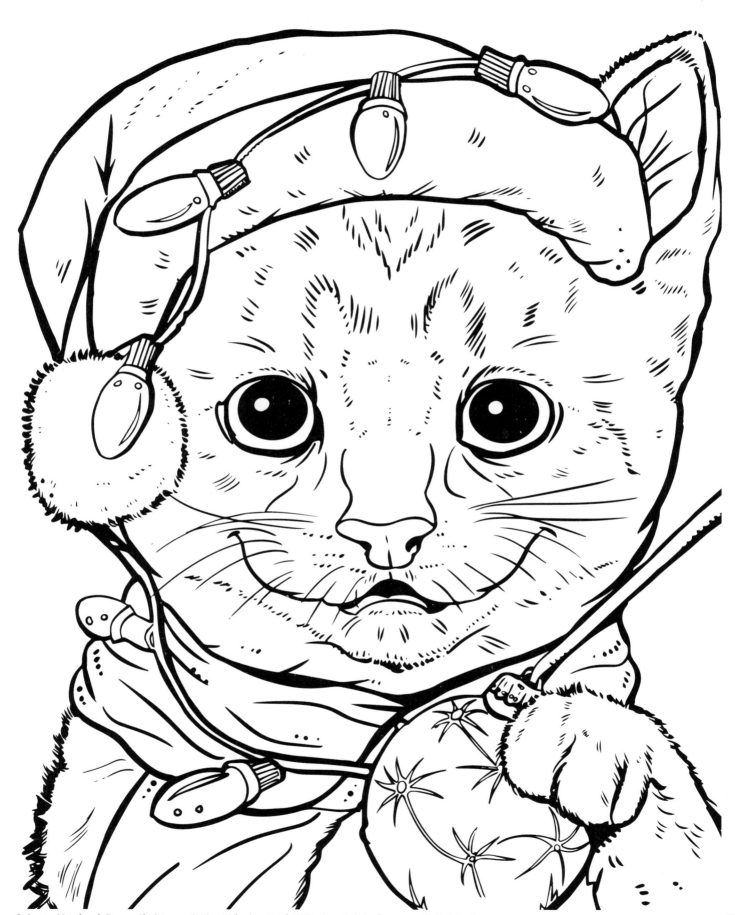

A kitten is, in the animal world,
what a rosebud is in the garden.

—Robert Southey

Always Playing

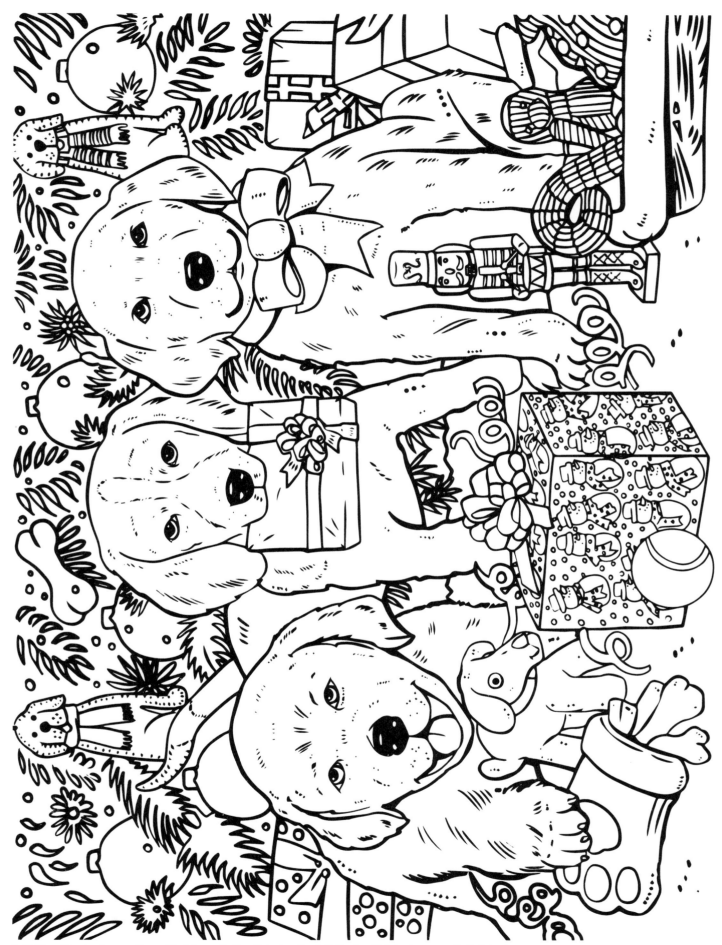

Dogs are obsessed with being happy.

—James Thurber

The Best Time

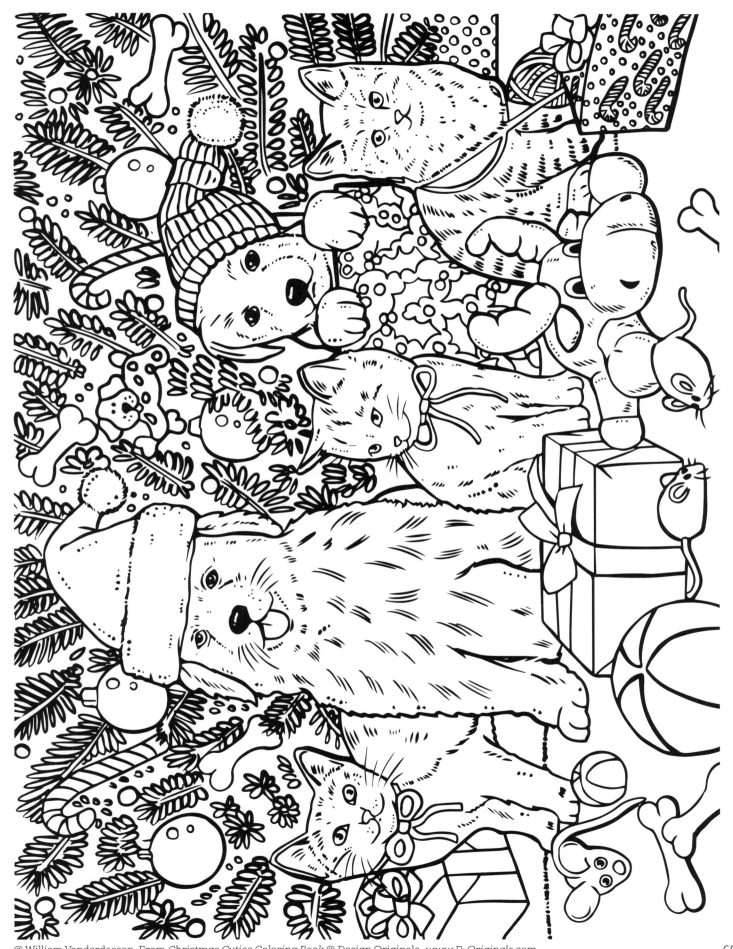

Inside every Newfoundland, Boxer,
Elkhound, and Great Dane is a puppy longing
to climb on to your lap.

—Helen Thomson

Sharing Toys

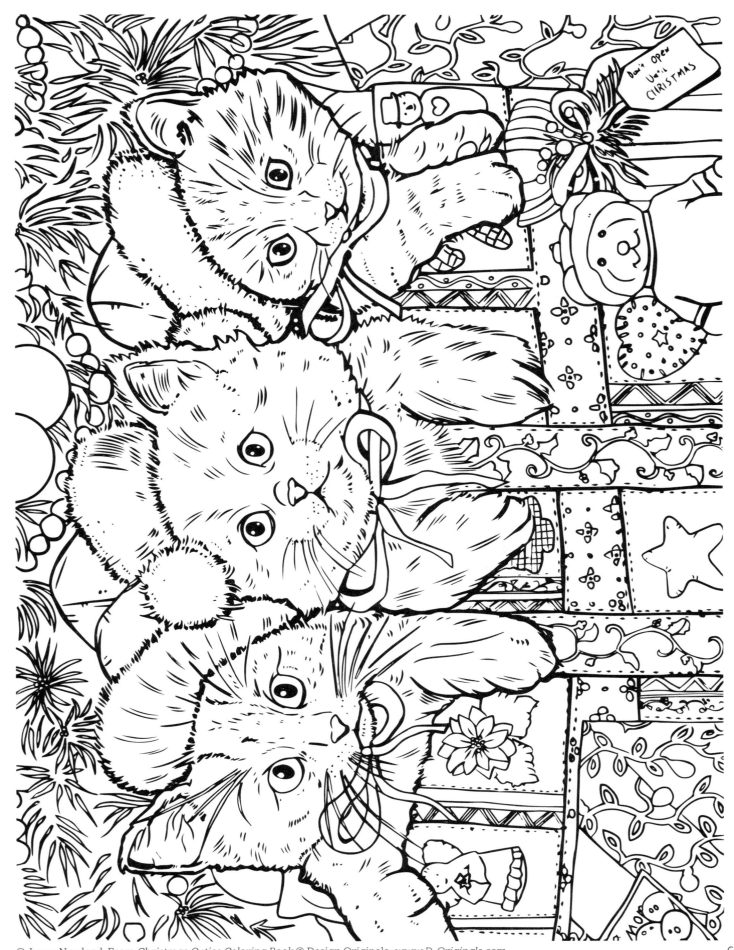

I love cats because I enjoy my home; and little by little, they become its visible soul.

—Jean Cocteau

A Special Present

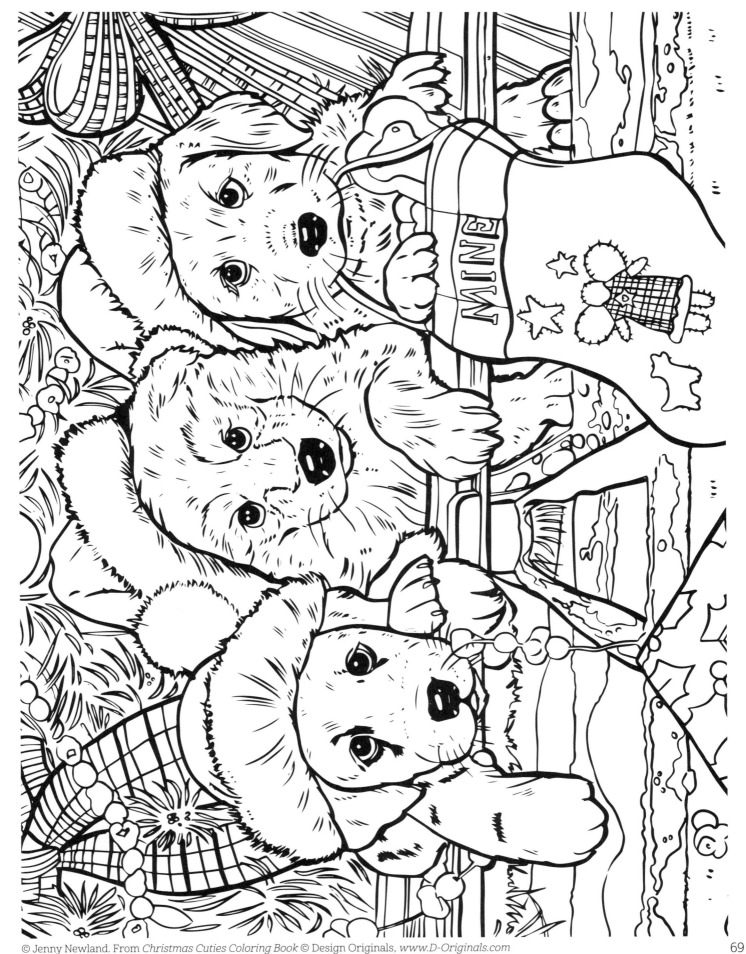

One of the most glorious messes in the world is the mess created in the living room on Christmas day. Don't clean it up too quickly.

—Andy Rooney

Christmas Morning

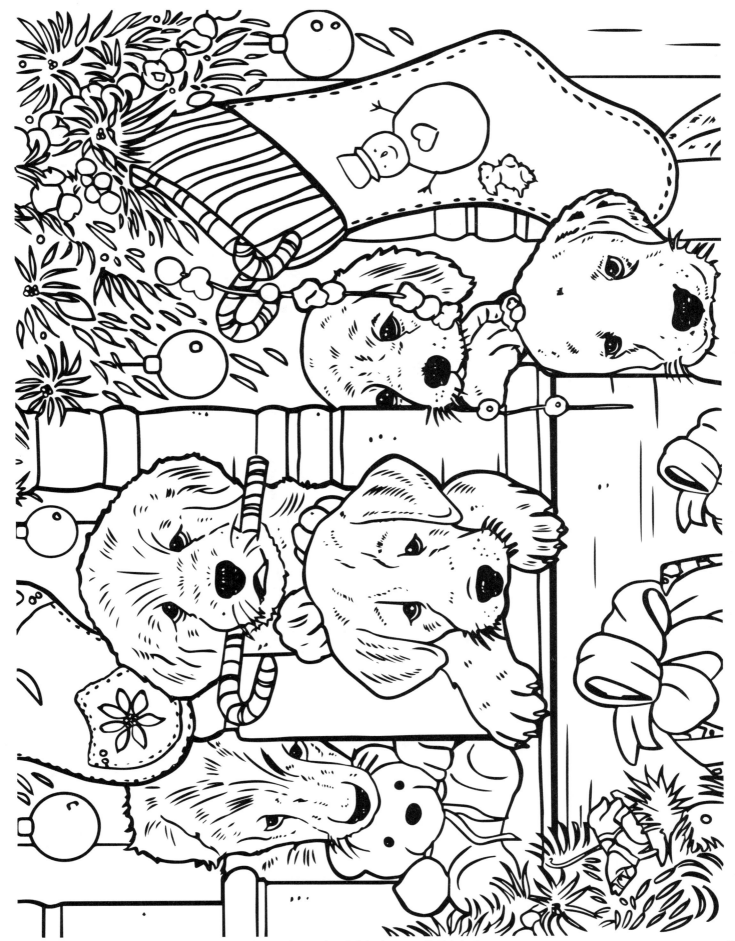

Petting, scratching, and cuddling a
dog could be as soothing to the mind
and heart as deep meditation.

—Dean Koontz

Did Santa Come?

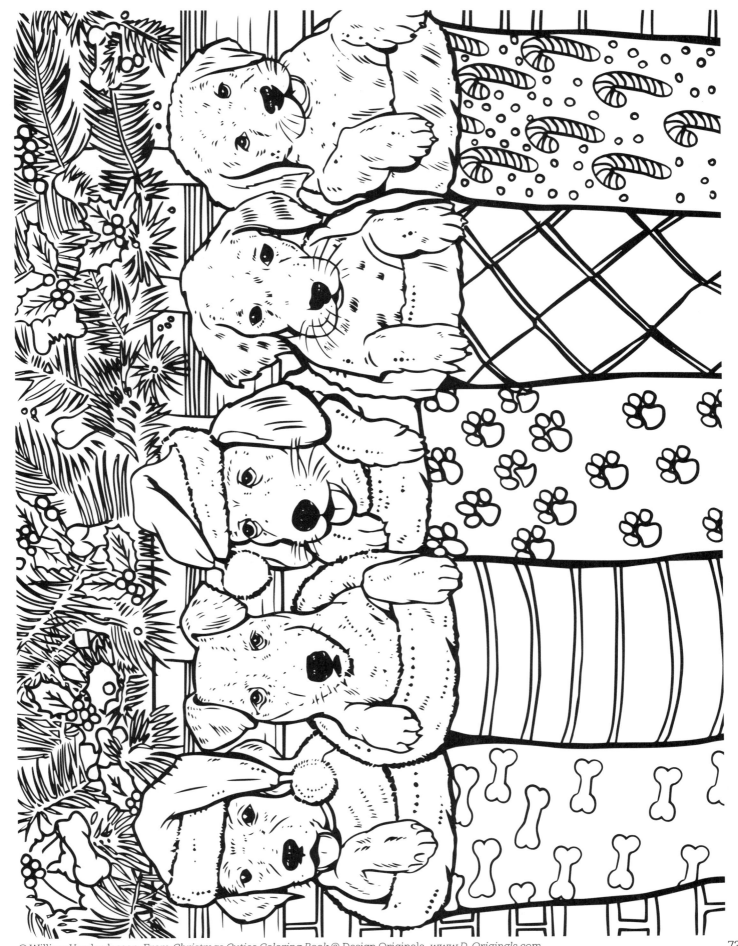

No symphony orchestra ever
played music like a two-year-old
girl laughing with a puppy.

—Bernard Williams

Best Gift Ever

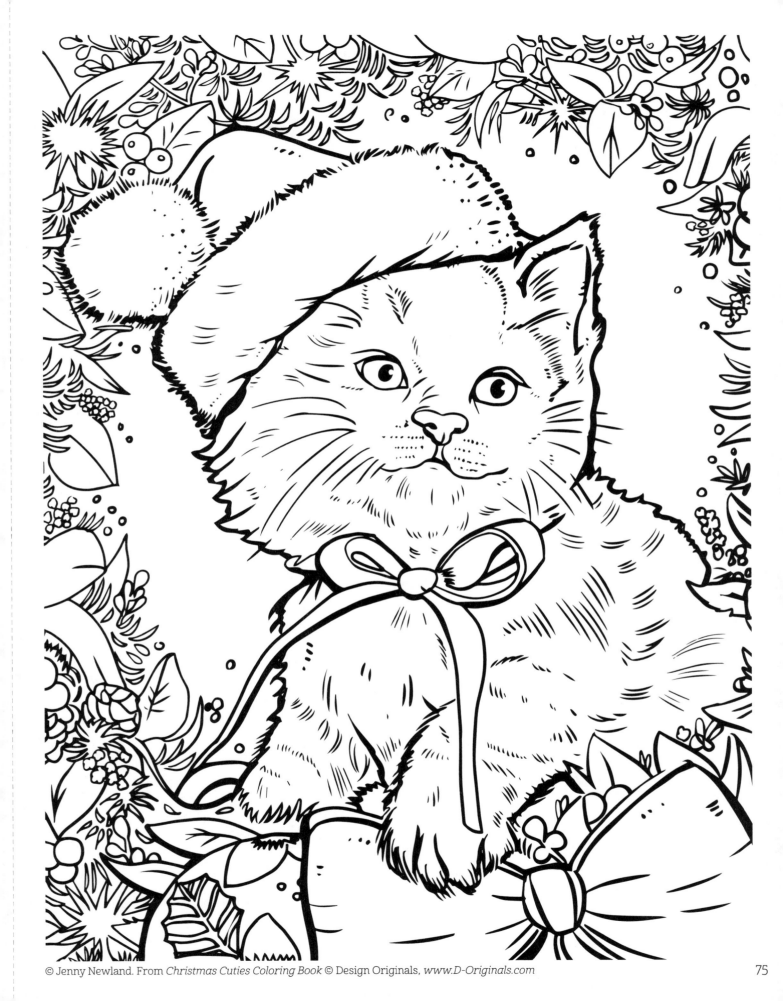

May Christmas lend a special charm
To all you chance to do.
And may the season light your way
To hopes and dreams anew.

—Garnett Ann Schultz, *My Christmas Wish*

Kitty Wreath

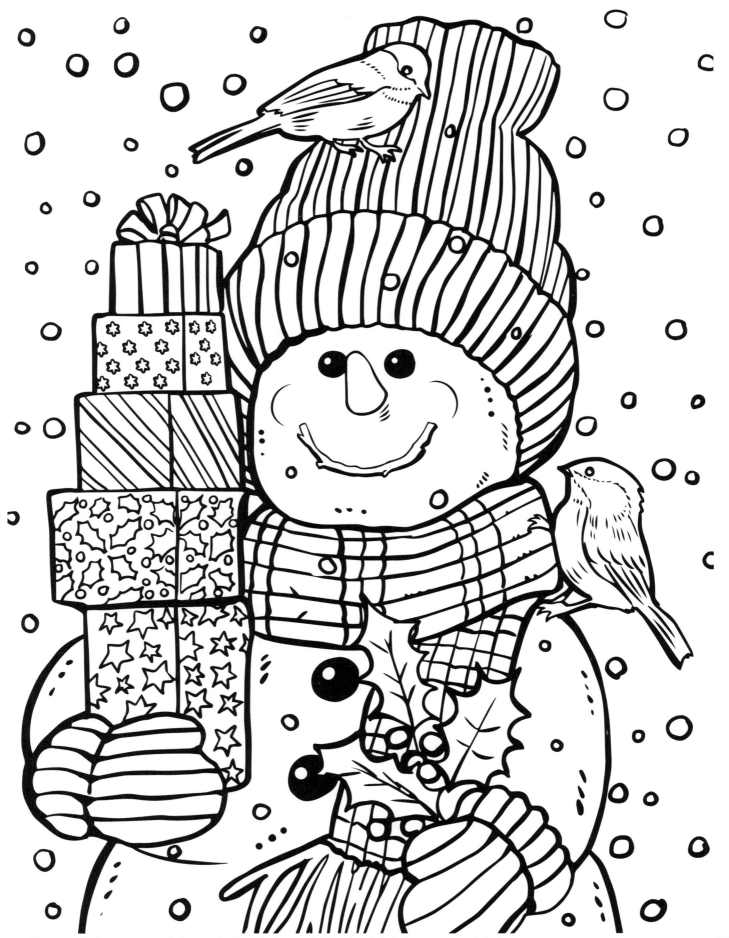

Sing hey! Sing hey!
For Christmas Day;
Twine mistletoe and holly.
For a friendship glows
In winter snows,
And so let's all be jolly!

—Unknown

Holly, Jolly Snowman

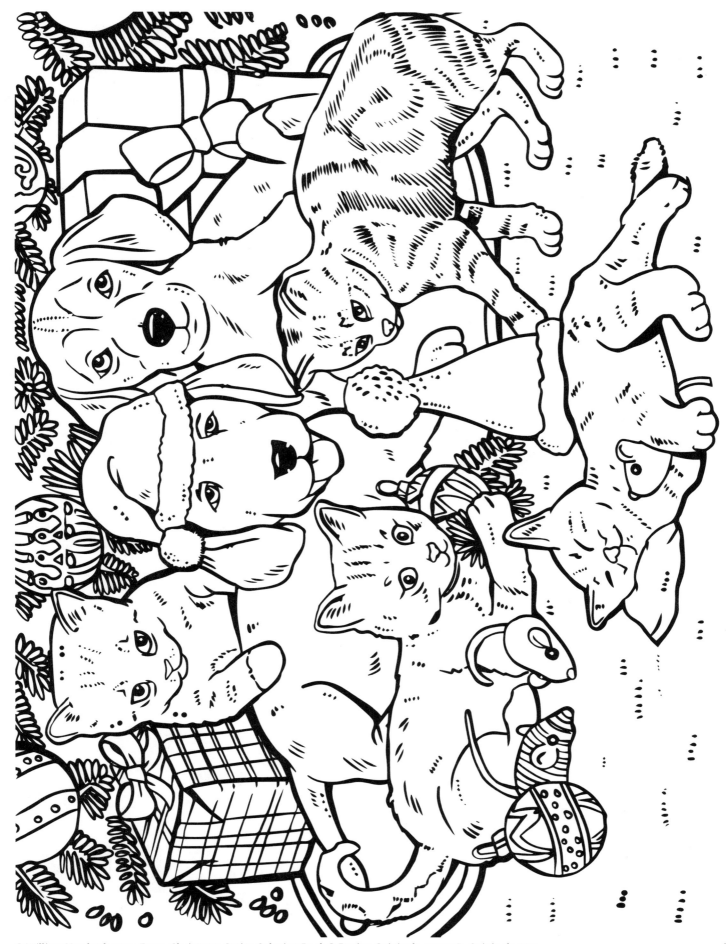

Sometimes, the smallest things take up the most room in your heart.

—A. A. Milne, *Winnie-the-Pooh*

Peace and Joy